墨

世

MEXICAN
MODERNITY

鼎

新

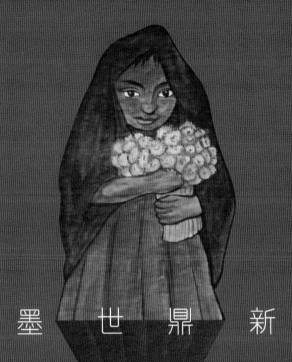

墨　世　鼎　新

MEXICAN
MODERNITY
20TH-CENTURY PAINTINGS FROM
THE ZAPANTA MEXICAN ART COLLECTION
薩潘塔墨西哥藝術收藏之二十世紀繪畫

香港大學美術博物館
University Museum and Art Gallery
The University of Hong Kong

MEXICAN MODERNITY
20TH-CENTURY PAINTINGS FROM THE ZAPANTA MEXICAN ART COLLECTION
墨世鼎新：薩潘塔墨西哥藝術收藏之二十世紀繪畫

CURATORS 策展人
GREGORIO LUKE 格雷戈廖‧盧卡
DR. FLORIAN KNOTHE 羅諾德博士

PUBLISHER 出版
CHRISTOPHER MATTISON 馬德松
UNIVERSITY MUSEUM AND ART GALLERY,
THE UNIVERSITY OF HONG KONG
香港大學美術博物館

CHINESE TRANSLATION 中文翻譯
EDWARD ZHOU 周政

PHOTOGRAPHY 攝影
VICTOR PARRA

DESIGN 設計
PAULINE HO 何寶妮

EDITION 版次
JUNE 2016
二零一六年六月
© University Museum and Art Gallery,
The University of Hong Kong, 2016

ISBN 國際標準書號
978-988-19023-6-8

UNIVERSITY MUSEUM AND ART GALLERY,
THE UNIVERSITY OF HONG KONG
90 Bonham Road, Hong Kong
香港大學美術博物館
香港般咸道九十號

ORGANISED BY 主辦

香港大學美術博物館
University Museum and Art Gallery
The University of Hong Kong

SUPPORTED BY 支持

CONTENTS
目次

FOREWORD
前言

DR. FLORIAN KNOTHE
DIRECTOR
UNIVERSITY MUSEUM
AND ART GALLERY
THE UNIVERSITY OF
HONG KONG

The University Museum and Art Gallery is delighted to be collaborating with Richard and Rebecca Zapanta on this retrospective exhibition of Mexican avant-garde painting. Over the past 25 plus years, the Zapantas have collected some of the best-known and most artistically influential Mexican artists, including José Clemente Orozco, Diego Rivera, Rufino Tamayo and Frida Kahlo.

Mexican Modernity displays, through 40 paintings, the development of painterly styles and social representations, from the more European influenced compositions to predominantly indigenous themes that regularly appeared as liberal México sought to distinguish itself from its Spanish colonial past. The exhibition aims to introduce the different, and at times unique, styles, such as muralist art and *neomexicanismo*, and to highlight the importance that local painters played in the development of neo-expressionist and postmodern art, as well as the colour palette and compositions that are today celebrated as significant contributions.

In México, artistic expression is often closely linked to societal change and political regimes. Consequently, this exhibition naturally lends itself to a discourse on the seismic shifts of Central America and the important achievements of the Latin-American community. Stimulated by local events and developments, the broad range of artistic styles and expressive visual narratives became influential abroad, and established an important place in history for Mexican artists.

We would like to thank Richard and Rebecca Zapanta for sharing their art collection with Hong Kong. We are honoured to display these essential works that define 20th-century México in the year that the Mexican Government is celebrating 50 years of representation in Hong Kong. We also would like to congratulate the Mexican Consulate on this milestone anniversary and to thank them, as well as the Mexican Agency for International Development Cooperation and the United States México Cultural and Educational Foundation, for their support.

香港大學美術博物館很榮幸有此機會，同理查德·薩潘塔與麗貝卡·薩潘塔一家合作舉辦是次展覽，追溯墨西哥前衛藝術繪畫的前世今生。在超過二十五年的收藏歷史中，薩潘塔家族已收藏眾多由最著名、最具藝術影響力的藝術家創作的作品，包括迪亞高·里維拉，羅勳奴·塔馬約，芙烈達·卡蘿。

《墨世鼎新》展覽通過四十件繪畫作品，展示了繪畫風格與社會表述的發展演進，即從受歐洲影響的創作到以本土主題為主導，這通常表現為自由主義的墨西哥為脫離西班牙殖民歷史而奮鬥。是次展覽力求介紹許多不同甚至獨特的藝術風格，比如壁畫藝術與新墨西哥主義藝術，並且著重表現出那些在新表現主義與後現代主義藝術發展中扮演重要角色的本土畫家，以及在今日藝術世界具有巨大意義的色彩模式與創作。

在墨西哥，藝術表現通常與社會及政權的變更相關緊密。因此，是次展覽自然亦是對中美洲巨變與拉丁美洲取得的重要成就的一次集中再現。受本土事件與發展的刺激，其豐富多樣的繪畫風格與極富表現力的視覺表述，踏出國門取得非凡影響，並將墨西哥藝術家群體永久鐫刻在藝術史冊中。

感謝理查德與麗貝卡同香港分享其藝術收藏，亦很榮幸值此墨西哥政府派駐香港五十週年慶典之際，舉辦是次魅力非凡的二十世紀墨西哥藝術展。感謝墨西哥駐香港總領事館，也要感謝墨西哥國際合作署與美國墨西哥文化教育基金會的支持幫助。

羅諾德博士
香港大學美術博物館總監

FOREWORD
前言

JAMES CUNO
PRESIDENT AND CEO
J. PAUL GETTY TRUST

The Zapanta Collection is, like all great collections, highly personal. The artworks were acquired because the Zapantas fell in love with each individual work. Many of them, like those by Rodolfo Morales and Raúl Anguiano, were acquired through a friendship with the artists. And these personal connections matter to Rebecca and Richard. The paintings and drawings they have collected are artefacts of personal relationships, theirs with the artists who made the works, and theirs with friends with whom they share the art.

In this exhibition, the Zapantas have generously allowed the collection to travel to the broad, cosmopolitan communities of Hong Kong and Manila. They want their collection to be seen and enjoyed by people who might never before have seen works made by Mexican artists, but who bring to the experience a hunger for new knowledge.

The Zapantas are proud of their Mexican heritage, just as they are proud of their U.S. and Los Angeles identities. In this way, and much like the works in their collection, they are ambassadors dedicated to bringing people together over the shared experience of viewing works of art. For this they should be greatly admired and deeply thanked.

薩潘塔收藏與所有偉大收藏相同，極具個人特色，其中囊括的每件藝術品皆緣起自薩潘塔家族的喜好與審美。薩潘塔一家與羅多爾福·摩拉利斯、勞爾·安吉亞諾等藝術家結下的友誼，使其得以收藏到他們的作品，而這些私人關係對理查德與麗貝卡而言亦極其重要。他們收藏的繪畫與素描作品，是其與藝術同好們的交流之橋，亦構建起他們與藝術創作者之間的聯繫。

在是次展覽中，薩潘塔家族慷慨借出收藏，漂洋過海來到國際大都會之城，香港與馬尼拉。他們希望那些從未見識過墨西哥藝術，但同時亦對新知識有所渴求的人們，皆能暢遊在其收藏藝術的海洋之中。

作為美國洛杉磯居民的薩潘塔一家，為其墨西哥後裔的身份感到無比自豪。在此維度中，他們正是文化交流大使，致力於通過收藏的方式將人們匯聚一堂共享藝術品之美。薩潘塔一家值得被人尊崇，在此，謹向他們致以最誠摯的感謝！

詹姆斯·坤諾
J·保羅·蓋蒂基金會主席
兼行政總裁

FOREWORD
前言

GREGORIO LUKE

As a fourth generation Mexican-American, collecting contemporary art has become a way for Richard Zapanta to reconnect with his roots. When selecting art, he employs a highly methodical approach, intensely studying traditional and emerging artistic styles, keeping abreast of current exhibitions, analysing auction trends and always insisting on viewing the artworks in person before making a purchase.

The result of these efforts is a significant collection of 20th-century Mexican art that includes examples of nearly all of the relevant styles and primary figures. The Zapanta Mexican Art Collection has been exhibited in numerous museums throughout the United States, and now is being shown for the first time in an international venue.

A defining characteristic of the collection is the personal relationship that Dr. Zapanta establishes with the artists. Friendships lead to advocacy, and Richard and his wife Rebecca have been instrumental in organising exhibitions and securing public commissions for Mexican artists across the United States.

There also is a highly social dimension to the Zapanta Collection. Their home is always open to civic leaders, businessmen and politicians, to young professionals and art enthusiasts alike. Many have discovered México on the walls of their home; others have been inspired to begin their own collections or even to become artists themselves.

理查德‧薩潘塔是第四代墨西哥裔美國人，而收藏現代藝術品恰已成為其尋根問祖的方式。在挑選藝術品方面，薩潘塔自有一套精心設計的系統方法與評測準則，他總是認真鑽研傳統及新創的藝術風格，時刻關注展覽資訊，分析拍賣趨勢，並堅持在收藏前親往觀察體驗。

終於，在薩潘塔的辛勤耕耘之下，其藏品已成為二十世紀墨西哥藝術領域中的重要收藏，涵蓋了幾乎所有的相關風格與主要人物。薩潘塔墨西哥藝術收藏已於遍佈美國的眾多博物館展出，今次乃是其首次走向國際。

薩潘塔與這些藝術大師之間的私人友誼，亦是其收藏的典型特徵，而他與妻子麗貝卡更將這種友誼升華為尊崇，致力於為這些身在美國的墨西哥藝術家籌備展覽，爭取公眾委任。

薩潘塔收藏在社會維度中亦有深刻的意義。他們的家永遠向公民領袖、商人與政治家敞開，亦是青年藝術專家及愛好者的避風良港。薩潘塔向許多人展示了完整的墨西哥，也啟迪了許多人的收藏事業與藝術生涯。

格雷戈廖‧盧卡

GREGORIO LUKE

EARLY MASTERS

Unique to the timeline of the UMAG exhibition is the early colonial work, *Our Lady of Sorrows*, a graceful and iconic Madonna painted by **Miguel Cabrera** in 1761. Cabrera is widely referred to as the master of Colonial México, based on his significant influence as the official painter for the archdiocese of México, and for the fact that he founded and served as director for the Academy of Painting in México City. Cabrera is best known for his historical and religious portraits, including the poet and nun Sor Juana Inés de la Cruz and his copy of the icon of Our Lady of Guadalupe. Predating the other paintings in the exhibition by more than a century, the work is an originary moment highlighting an exquisitely radiant Madonna emerging from the darkness. Illuminated solely by a spiritual light emanating from within, the viewer's gaze is focused on the Madonna's expression and cupped hands, which follows the stylistic tradition of Renaissance painter Francisco de Zurbarán (1598–1664).

Dr. Atl (Gerardo Murillo, México 1875–1964), one of México's most luminary and early modernists, is represented by the elegant charcoal drawing *Paisaje con la Luna Llena* (Landscape with Full Moon). The piece is charged with an ethereal drama that draws one into the rustic landscape. Murillo worked under his Aztec name Atl (Náhuatl for "water") as a response to imported Spanish colonial traditions and as a demonstration of pride for his Mexican Indian heritage. Murillo organised a seminal exhibition of contemporary Mexican art at the Academy of San Carlos in 1910, which included fifty satirical drawings by José Clemente Orozco. Murillo's iconic landscape paintings of México are the basis of an indigenous modern artistic style in search of universal meaning among México's volcanoes and grand vistas.

Alfredo Ramos Martínez's (1871–1946) *Returning Home from the Market* displays a landscape of cubist rocks and dark mountain ranges that frame an indigenous field worker within a geometric composition. Often referred to as the father of Mexican Modernism, Martínez spent a decade in turn-of-the-century France, where he came to know Picasso, Monet and numerous other artists. Returning home early in 1910, at the brink of the Mexican Revolution, he was named director of México City's art academy. He immigrated to the US in the late 1920s, remaining in relative obscurity for several years, overshadowed by such figures as Diego Rivera and other celebrity muralists. Recently his work has been re-discovered, and he is now considered to be one of México's most influential artists, both for his work produced in México and across southern California.

Roberto Montenegro (1887–1968) drew inspiration from the European symbolism of the *fin de siècle*; he was likewise well versed in forms of popular Mexican folk art. Montenegro began his art education in Guadalajara, México, and later attended the Academy of San Carlos in México City with painters such as Diego Rivera. Montenegro's painting *The Bird Woman* is representative of his unique blend of ancient, religious and popular styles and techniques. The woman in the painting holds a basket over her head, assisted by magical birds. The figure is presented as a flat plane with a gold-leaf background shimmering behind.

MURALISTS

The Zapanta Collection features several works by México's three greatest muralists, who were known simply as *Los tres grandes*: José Clemente Orozco,

Diego Rivera and David Alfaro Siqueiros. These muralists rejected the Eurocentric academic styles emphasised by the Porfirio Díaz government. Inspired by the Mexican Revolution (1910–1921), and commissioned by the new education secretary José Vasconcelos, the artists promoted a social agenda for making art accessible to the masses, and for reviving interest in México's indigenous past, popular art and revolutionary politics. From the 1920s–1950s, *Los tres grandes* and their compatriots developed a bold artistic style that defined a new Mexican identity.

José Clemente Orozco (1883–1949) began his career painting images of prostitutes in México City, as in his series *Casa de Lágrimas* (House of Tears). *Mujer Sentada* (Seated Woman) highlights Orozco's break from classical styles of the female nude, which is enhanced by the partial female bust placed on a Greek pedestal in the background and the dissected female figure in the foreground. For Orozco, art was a vehicle for denouncing social injustice, hypocrisy and political oppression. In many of his murals, neoclassical structures are replaced by cubist figures and native iconography, signaling the beginning of a new world order, and the hope for a more egalitarian society.

The most famous of the Mexican muralists, **Diego Rivera** (1886–1957), painted indigenous people with great dignity and beauty. Of particular note in the painting *Niña con Flores* (Girl with Flowers), is his mastery of colour, highlighted by an exquisite combination of orange hues on the cobblestones, the girl's dress, the bouquet of flowers and the lit candles in the background. The other Rivera work in the collection depicts Mexican revolutionary Emiliano Zapata with a white horse. This lithograph is one

of his most famous works, which was extracted from his mural cycle painted on the walls of the *Palacio de Cortés* in Cuernavaca.

David Alfaro Siqueiros (1896–1974) was a deeply political artist who fought as a soldier in both the Mexican Revolution and the Spanish Civil War. Influenced equally by religious art and Italian Futurism, Siqueiros's monumental forms and dynamic works were matched only by his political activism, which resulted in jail time and exile. In *Filantropía en Vacaciones* (Philanthropy on Vacation), he expresses his disgust for the injustices of the social class system, represented by the frivolous animation of the three upper-class carnivalesque women, in contrast to the modest, Madonna-like peasant mother and child.

SECOND GENERATION MURALISTS

The Zapanta Collection includes a strong selection of second generation Mexican muralists, with works by Raúl Anguiano, Jesús Guerrero Galván, Alfredo Zalce, Francisco Zúñiga, Federico Cantú and Gustavo Montoya. These artists continued the ideology of the Mexican School and were loyal to the nationalist and social ideals of their predecessors, including the foundational works by *Los tres grandes*. A combination of indigenous motifs and European-influenced artistic styles were used to continue the glorification of the Mexican Revolution and the developing mestizo nation, as México shifted from being a largely agrarian to an industrial society.

The Zapanta Collection has one of the world's best collections of paintings by **Raúl Anguiano** (1915–2006). *Mendiga* (Beggar) reveals Anguiano's ability to communicate his subject's emotional state through body language and posture. The poor woman's suffering is immediately

felt through her outstretched hand and hidden face. Anguiano's knowledge of ancient Mexican art is reflected in the still life, *Máscara y Naranja* (Mask and Orange) and *Presencia del Hombre Maya en las Olimpiadas* (Mayan Man's Presence at the Olympics), a monumental oil on canvas painted for the 1984 Los Angeles Olympics. It contrasts the Mayan figure rendered in colour with the figures of an eagle and snake, which represent the feathered serpent *Quetzalcoatl*, an indigenous deity of wisdom. Anguiano is particularly well known for his paintings of female figures. This collection offers two excellent examples: *Oriental Beauty* and a re-creation of his most famous painting titled *La Espina* (Thorn). This painting depicts a contemporary Mayan woman extracting a thorn from her foot in a deforested landscape. Throughout Anguiano's work, he painted the Mexican Indian not as a mythical figure but as a relevant member of contemporary society. Anguiano created this work for the Zapanta Collection in gratitude for their efforts in securing a commission for him at East Los Angeles College.

Jesús Guerrero Galván (1910–1973), a technical virtuoso of colour, infused his work with a lyrical realism and profound sense of spirituality. In *Untitled*, the landscape focuses on a young boy listlessly sleeping on a volcanic rock that is warmly illuminated in the radiant atmosphere. Associated with both the muralists and the modernist easel art movement, Galván routinely included a social statement in all of his work, or at least a tiny red star, echoing his beliefs about the necessary synthesis of revolution and art.

Alfredo Zalce (1908–2003) was an accomplished muralist and printmaker. Based on his travels through México in the early 1930s–1940s, he dedicated himself to representing the social struggles of the rural

working class. Among the wide variety of media in which he worked, Zalce was the first contemporary muralist to use the traditional medium of coloured cement in modern work. His handsome charcoal drawing, *Still Life with Watermelon* employs a common 20th-century Mexican metaphor for national identity.

Federico Cantú's (1908–1989) *La Despedida* (The Farewell) balances a tranquil Madonna figure holding a red rose, a symbol of reverence, with a group of fishermen in the background, for whom her benevolent blessing oversees their work. This painting is emblematic of Cantú's incorporation of everyday life and people into his religious imagery.

Francisco Zúñiga (1912–1998), born in Costa Rica, became México's most important sculptor. He also was a talented draftsman. *Madre y Niño* (Mother and Child) and *Mujeres en el Mercado* (Women at the Market) are iconic examples of his perception of the female in Mexican society. Monumental, proud female figures sit or stand firmly upon the earth's fertile soil. *Familia con Burro* (Family with Donkey) is another dignified work that has as its primary subject a proud mother and child.

Gustavo Montoya (1905–2003) is most celebrated for his colourful paintings of children who generally appear against muted backdrops. In *Dos Niños, Uno Jugando* (Two Children, One Playing) Montoya's traditionally dressed subjects are highly stylised; the emphasis in the painting is placed on the interplay of light and colour.

WOMEN ARTISTS

During the first half of the 20th century, the aesthetic and political ideals of the muralists became almost synonymous around the world with Mexican art. In aesthetic opposition to the muralists, several important women artists created quite different types of work, which often were inspired by surrealism and everyday life. Instead of murals, they created intimate works, and instead of addressing historical and social issues, they spoke about their own personal concerns and inner worlds.

The most important of these artists was **Frida Kahlo** (1907–1954). Original Kahlo works are now quite rare, and Richard Zapanta put great effort into acquiring this intimate drawing for his collection. *Por la Paz* (For Peace) was recently exhibited in the Kahlo retrospective in Berlin at the Martin-Gropius Bau and in Vienna at the Kunstforum Wien. The drawing is a self-portrait of Frida in her signature Tehuana dress; below her appear four figures in profile and frontal view. The words "Por la Paz" were written on a protest sign that Frida carried in a political rally against the military coup in Guatemala, prior to her death in 1954.

Two other distinguished women artists featured in the collection are **Leonora Carrington** (1917–2011) and **Olga Costa** (1913–1993). Carrington was a British-born surrealist who lived most of her life in México. *Tuesday (State II)* is characteristic of the fantastic dreams she painted of a world populated by magical animals and enchanted beings. Carrington was fascinated by the unconscious mind, and her dream imagery explores issues of México's rapid transformation and sexual identity. Costa, like Carrington, emigrated to México from Europe. However, instead of the fantastic, she painted familiar daily scenes and commonplace objects. *Casa Azul* (Blue House) is a work of great simplicity and charm.

LA RUPTURA

During the mid-'50s and '60s, a new generation of Mexican artists challenged the hegemony of the Mexican School. This movement is known as *La Ruptura* (The Rupture). These artists believed that México should join the larger international art world and paint images more representative of the mid-20th-century's fractured and decaying realities, rather than the romanticised past created by the muralists.

The most vocal of these artists is **José Luis Cuevas** (b. 1934): *Frequentas of 42nd Street* (42nd Street Regulars), *La Feria de Oklahoma* (Oklahoma Fair) and *El Obrador de Juan Carreño*. (The Workroom of Juan Carreño). Cuevas has rejected the luminous colors of Diego Rivera, creating a dark and decadent world. Cuevas has vowed to "Cross the cactus curtain", meaning that instead of rural and indigenous scenes, Mexican artists should paint the urban realities of disparity, blight and misfortune.

Another member of *La Ruptura*, **Rafael Coronel** (b. 1931), has sought a more universal definition of Mexican art. In his work, Coronel focuses on themes of homelessness and the lives of street people. However, he paints them with elegance and dignity, as if they were members of the nobility. *Carperos II* depicts three popular theatre performers who carry out their shows in portable tents known as *carpas*. The other work by Coronel, *The Grandfather*, is a study of a man nearing death. The drama is communicated through the combination of a forceful drawing and sombre palette.

As a result of *La Ruptura*'s revolt, the next generation of Mexican artists was free to explore a diversity of styles. Two artists from this generation could not be more different. **Alfredo**

Castañeda (b. 1938) obsessively paints quasi-autobiographical and obese characters with long beards. *Saludo* (Greeting) features an outline of a disembodied hand, and is a sophisticated example of Castañeda's style. In contrast, **Emilio Ortiz** (b. 1936) returns to rural scenes of México in simplified and naïve compositions such as *Niño* (Boy).

THE OAXACAN MOVEMENT

Over the past few decades, the most important artistic movement in México has originated in Oaxaca. It is characterised by vibrant colors and the re-interpretation of pre-Hispanic artistic traditions.

As an orphan, **Rufino Tamayo** (1899–1991) spent his youth working as a fruit vendor. Later he worked on the pre-Hispanic collection in the National Museum, where he was given the task of drawing and cataloguing every piece in the collection. This experience was transformative, and enabled him to conceive of a new form of Mexican art based on pre-Hispanic work and the intense colours of México. He lived in New York and connected his artistic language to the larger contemporary art world. The Zapantas befriended Tamayo. His work is well represented in this show by two lithographs: *Black Venus* and *Perfil* (Profile), as well as in the drawing *Figura* (Figure) and the mixograph *Niña*. The mixograph process was developed in collaboration with Tamayo, as he wanted his prints to maintain the depth and varied relief work in his paintings. Tamayo was always in search of modes of synthesis. These particular works are admirable for their economy of line and colour.

Even though he was world famous, Tamayo always made time to encourage new talent.

His influence was felt across México, especially by artists such as **Vladimir Cora** (b. 1951) from Nayarit, as seen in *Mujeres en la Puerta* (Women at the Door), and **Alejandro Colunga** (b. 1948) from Guadalajara. Although Colunga also drew inspiration from artistic movements such as American Pop Art, Tamayo's influence is unmistakable in his magnificent *Mago de la Lluvia* (Rain Magician). Tamayo succeeded brilliantly in promoting artists in his native Oaxaca, especially Rodolfo Morales and Francisco Toledo.

Rodolfo Morales (1925–2001) was the ultimate late bloomer in terms of Mexican art. Morales was a particularly reserved and humble artist, working tirelessly as an art teacher for thirty years. One day, while organising a party at the home of the sculptor Geles Cabrera, he used his own collages as decorations. Cabrera was so impressed by his work that she organised an exhibition for him. Tamayo then saw his works and began to promote him. After the Zapantas met Morales, they had him stay with them for a short period of time, and hosted a party in his honour. Remarkably shy, he noted that he was not very good at talking, only painting. So, Rebecca Zapanta accompanied him to a local art store to buy brushes, paints and canvases. After the guests arrived, Rodolfo Morales began to create exquisite paintings and collages.

Rodolfo Morales' paintings have had great success on the international art scene. During his life, what was even more remarkable was what Rodolfo Morales did with the proceeds from the sale of his works. He continued to live humbly, and invested his earnings in a foundation to restore the colonial buildings in his town of Ocotlán. The three Rodolfo Morales works chosen for this exhibition are masterpieces of magic-realism; two oils on canvas and one collage.

Francisco Toledo (b. 1940), another artist encouraged by Tamayo, is now widely considered to be México's greatest living artist. *Composition Au Cheval* (Composition with Horse) is a significant example of his vision. Like Morales, Toledo has had an enormous impact on his hometown; he has established numerous institutions, among them an art library, a library for the blind and a musical library. Toledo has become a patriarch, constantly defending the cultural patrimony of Oaxaca. In his art, Toledo penetrates the sacred dimension of life; he explores ancient myths and magic with seriousness and simplicity.

薩潘塔墨西哥藝術收藏：展覽說明

格雷戈廖‧盧卡

早期大師

不同於是次香港大學美術博物館展品的主要創作時序，《痛苦聖母》是一件與眾不同的早期殖民地時期作品，乃是由米格爾‧卡布瑞拉於一七六一年創作的聖母瑪利亞的優雅聖像。卡布瑞拉對墨西哥教區的官方畫家群體具有重要的影響，而且還曾創立墨西哥城畫院並親自擔任總監，故而被尊奉為殖民地墨西哥時期的藝術大師。卡布瑞拉的歷史及宗教肖像最為著名，包括詩人修女胡安娜‧伊內斯‧德拉克魯茲，以及他的「瓜達露佩聖母」聖像作品。《痛苦聖母》是一幅獨特的卡布瑞拉作品，早於其他展品一世紀以上，畫中典雅的聖母從黑暗中顯現而出，被一道由內而外的靈光照亮，將觀者的眼神吸引至聖母的面部表情與合十的雙手，此種傳統風格追隨了西班牙文藝復興畫家法蘭西斯科‧德‧祖巴蘭（一五九八年至一六六四年）。

阿特爾博士（謝拉度‧牟利羅，墨西哥人，一八七五年至一九六四年）是墨西哥最傑出的現代主義藝術先行者之一，在此由精美的炭筆畫《望境》所代表。作品中滿是縹緲的戲劇意味，將觀者領入這鄉村風景之中。牟利羅創作時使用其阿茲特克語的名字「Atl」（納華特文意為「水」），這是對於不斷輸入的西班牙殖民習俗的回應，也是在向世人宣誓繼承墨西哥印第安遺產。一九一零年，牟利羅於聖卡洛斯藝術學院籌劃了一場具有劃時代意義的當代墨西哥藝術展覽，其中包括五十件荷西‧克萊門特‧奧羅茲科的諷刺素描作品。牟利羅標誌性的墨西哥風景畫在不斷找尋墨西哥火山群與壯麗風景的普適真義，這成為了墨西哥本土現代藝術風格的基礎。

阿爾弗雷多‧拉莫斯‧馬天尼斯（一八七一年至一九四六年）的作品《歸家》，展現了一片由立體派風格的石頭與深色山脈構成的風景，還在幾何形構圖中嵌入了一位土著農工的形象。拉莫斯‧馬天尼斯常被稱為「墨西哥現代主義之父」，他曾在世紀之交的法國生活十年，並結識畢加索、莫內等眾多藝術巨匠。一九一零年初，即墨西哥革命爆發前夕，馬天尼斯返回墨西哥，並受邀指導墨西哥城藝術學院的工作。二十世紀二十年代後期，他移居美國，但在迪亞高‧里維拉等其他名人壁畫家的光芒掩蓋之下，顯得相對默默無名。最近，他的作品價值被重新發現，包括其墨西哥時期的作品與南加州時期的作品，他如今也被視作墨西哥最有影響力的重要藝術家之一。

羅拔圖・蒙特內格羅（一八八七年至一九六八年）深受歐洲「世紀末」的象徵主義藝術影響，亦精通於各種流行形式的墨西哥民間藝術。蒙特內格羅最初在墨西哥的瓜達拉哈拉修習藝術，之後進入墨西哥城的聖卡洛斯藝術學院學習，同迪亞高・里維拉等畫家成為同學。蒙特內格羅的繪畫作品《鴿女》，充分表現了他的獨特藝術風格，即融匯了古代的、宗教的與流行的風格與技藝。畫中的女人在神奇鴿子的協助下將一個籃筐舉在頭頂，人物以平面展現，金箔背景在背後閃著微光。

墨西哥壁畫家

荷西・克萊門特・奧羅茲科，迪亞高・里維拉與大衛・阿爾法羅・西凱羅斯是墨西哥最偉大的三位壁畫家，合稱「三大家」，其創作的數件作品皆是薩潘塔收藏中的珍品。他們堅決抵制由波費里奧・迪亞斯政府提倡的歐洲中心系學院派風格，而是借勢墨西哥革命（一九一零年至一九二一年），並受新任教育部長荷西・瓦斯康塞洛斯的任命，共同發起一場致力於藝術普及的社會變革，恢復人們對於墨西哥本土過往、流行藝術與革命政治的關注。二十世紀二十年代至五十年代，「三大家」及其同好們發展出一種大膽的藝術風格，這成為新的墨西哥藝術名片。

荷西・克萊門特・奧羅茲科（一八八三年至一九四九年）的藝術生涯始於「淚之屋」系列中描畫墨西哥城妓女的作品。薩潘塔收藏的《坐著的女人》突顯了奧羅茲科對於女性裸體古典式樣的擺脫與突破，這表現於背景中希臘式柱座上的部分女性半身像，以及前景中分裂的女性人物。對於奧羅茲科而言，藝術是抨擊社會不公、偽善與政治迫害的手段。在他的許多壁畫作品中，立體主義形象與本土肖像取代了新古典主義結構，預示著一種新的世界秩序的開始，也表明了對於更平等社會的嚮往。

是次展覽中的繪畫《女孩與花》，代表了最著名的墨西哥壁畫家之一，迪亞高・里維拉（一八八六年至一九五七年）的藝術，他在畫中展現了原住民的高貴與美麗。這幅作品中特別值得注意的是里維拉對色彩的高超掌控，這突出表現於圓石、裙子、花束與點燃的蠟燭上橙色調的精妙組合。收藏中的另一件里維拉作品，石版畫《薩帕塔》，是里維拉藝術生涯中最著名的作品之一，提取自他為位於庫埃納瓦卡的寇蒂斯宮創作的壁畫系列，展現了墨西哥革命領袖埃米利亞諾・薩帕塔手牽白馬的形象。

大衛・阿爾法羅・西凱羅斯（一八九六年至一九七四年）在根本上是一位政治藝術家，他曾於墨西哥革命與西班牙內戰中戰鬥。受宗教藝術與義大利未來主義的雙重影響，西凱羅斯創作的大型形態與活力作品只與其政治行動主義傾向相吻合，亦導致其入獄與被驅逐。《假中善人》通過三位正在狂歡的上層婦女的輕佻的動畫式形象，與謙和的農婦與孩童的形象形成鮮明對比，表現出對社會階層體系嚴重不公的深惡痛絕。

第二代壁畫家

薩潘塔收藏中有很多第二代墨西哥壁畫家的優秀作品，包括勞爾・安吉亞諾、赫蘇斯・格雷羅・加雲、阿爾弗雷多・扎爾斯、弗朗西斯科・蘇尼加、費德里戈・坎圖與古斯塔沃・蒙度亞。這些藝術家繼承了墨西哥畫派的觀念，並且忠誠於前輩藝術家的民族主義思想與社會理想。此種綜合了本土主題與受歐洲影響的藝術風格的新形態藝術，延續了墨西哥革命與麥士蒂索民族的榮耀，見證著從農業轉型為工業的墨西哥社會。

薩潘塔收藏有世界最優秀的藝術家之一，勞爾・安吉亞諾（一九一五年至二零零六年）的作品，是次展覽的五件作品代表了安吉亞諾的藝術。《乞婦》完美展現了安吉亞諾通過肢體語言與姿勢來表現描繪對象情緒狀態的能力，透過畫中伸出的手與隱藏的面容，觀者得以立即感受到這位可憐婦女的苦楚情緒。安吉亞諾對於古墨西哥藝術的認知反映在其靜物作品中，如《面具與橙》與《奧運會中的瑪雅人》，後者是為一九八四年洛杉磯奧運會創作的一幅具有紀念意義的布面油畫，其中的瑪雅人物經顏色渲染，與鷹和蛇的形象形成對比，再現了「羽蛇神」（魁札爾科亞特爾），即一位本土的智慧之神。安吉亞諾的女性人物繪畫尤為著名，薩潘塔收藏中有兩件傑出的範本，《東方麗人》與《刺》，後者是其最著名的繪畫作品的重製本，描繪了一位當代瑪雅女人正在一片砍伐殆盡的樹林風景下從腳中拔刺。總覽安吉亞諾的作品，他並非將墨西哥印第安人繪為神秘的形象，而是將其視作當代社會的

成員。安吉亞諾為薩潘塔收藏製作的這幅重製作品，特感謝薩潘塔為其在東洛杉磯學院獲得委任所做的努力。

赫蘇斯‧格雷羅‧加雲（一九一零年至一九七三年）是技藝精湛的色彩大師，為其作品注入抒情現實主義與充足的靈性。在《無題》中，風景聚焦於一個睡在火山岩上的捲怠的男孩，並在發光的氛圍中被暖亮。同壁畫家與現代主義架上藝術運動相聯繫的加雲，通常會在所有作品中加入社會主張，或至少是一個小紅星，以表現他必然綜合革命與藝術的理念。

阿爾弗雷多‧扎爾斯（一九零八年至二零零三年）是一位技藝精湛的壁畫家與版畫家。他於二十世紀三十年代遍遊墨西哥，這段經歷啟示他投身於再現農村工人階級社會掙扎的藝術實踐中。扎爾斯使用眾多媒介創作，是第一位在現代作品中應用傳統媒介彩色水泥的當代壁畫家。他漂亮的炭筆畫《靜物西瓜》是對於國家認同的一個二十世紀墨西哥式的常見比喻。

費德里戈‧坎圖（一九零八年至一九八九年）的作品《告別》，在手捧一束紅玫瑰（象徵崇敬）的平和的聖母形象與背景中的一群漁夫之間達到平衡，聖母慈愛的祝福眷顧著漁夫的日常工作。此作品是坎圖在其宗教圖像中融入日常生活與人物的代表。

弗朗西斯科‧蘇尼加（一九一二年至一九九八年），生於哥斯達黎加，不僅是墨西哥最重要的雕刻家，亦是一位天賦異稟的繪圖師。作品《母與子》與《市集中的女人》皆是他感知墨西哥社會中女性人物的標誌例作，畫中女人神采十足，身姿偉岸，在沃土之上堅定地或坐或立。《一家人與小驢》是另一幅凝重的蘇尼加作品，亦如其主要的描繪對象一般，展現了一位驕傲的母親與孩子。

古斯塔沃‧蒙度亞（一九零五年至二零零三年）因其在柔和背景上繪畫孩童的彩麗作品而聞名。在《兩個孩童，一人在玩》中，蒙度亞的描繪對象身著傳統服裝，高度風格化，作品的重點在於光和色之間的相互影響。

女性藝術家

二十世紀上半葉，壁畫家的審美與政治理念幾乎在世界各地代表著墨西哥藝術。但與壁畫家的審美趣味相反，數位重要的女性藝術家則通常受到超現實主義與日常生活的啟發，創造出截然不同的藝術。她們創作個人作品，而非壁畫；她們專注於談論個人的關注與表達內心世界，卻並非在解決歷史與社會問題。

芙烈達‧卡蘿（一九零七年至一九五四年）是此類藝術家中最重要的一位。卡蘿的原作目前極為難得，理查德‧薩潘塔投入巨大努力終將此幅作品納入其收藏。《和》最近於柏林的馬丁‧格羅佩斯展覽館與維也納藝術論壇中的卡蘿回顧展展出。此為芙烈達的自畫像，身著其標誌性的「特萬娜」禮服，下方則是四個側面像與正面像。卡蘿去世之前曾參與一次反對危地馬拉軍事政變的政治集會，其間她親自舉起的抗議標語上便書有「Por la Paz」（譯為：For Peace 為了和平）字樣。

薩潘塔收藏中另外兩位傑出的女性藝術家是李奧諾拉‧卡林頓（一九一七年至二零一一年）與奧爾加‧歌絲達（一九一三年至一九九三年）。卡林頓是一位超現實主義藝術家，生於英國，但絕大部分時間在墨西哥度過。其在《禮拜二》中描繪了奇幻夢境，居住著眾多神奇動物與迷人物種。卡林頓著迷於潛意識心理，以及關於急速轉型的墨西哥與性別認同等議題的夢中意象。與卡林頓相似，歌絲達亦是從歐洲移居墨西哥，然而其筆下並無奇幻，而是熟悉的日常場景與物品。《藍屋》便是一幅簡約、魅惑的歌絲達作品。

斷裂

上世紀五十年代中期至六十年代，新一代墨西哥藝術家挑戰墨西哥畫派的霸主地位，此運動被稱作「斷裂」。這些藝術家堅信墨西哥應該參與進更廣闊的國際藝術世界，並應創作能夠再現二十世紀中葉那種破碎與頹敗現實的作品，而不應像那些壁畫家一樣只關注浪漫主義的過往。

荷西‧路爾斯‧奎瓦斯（生於一九三四年）是這類藝術家中的旗手，在是次展覽中有三幅作品代表其藝術：《四十二街常客》、《奧克拉荷馬市場》與

《胡安‧卡雷尼奧的工作室》。奎瓦斯摒棄了迪亞高‧里維拉的明亮顏色，創造出一個黑暗與頹廢的世界。奎瓦斯誓要「越過仙人掌簾幕」，意求墨西哥藝術家創作不平等、破敗與不幸的城市現實，而非鄉村與原住民場景。

拉斐爾‧科羅內爾（生於一九三一年）也是「斷裂的一代」中的一員，他已尋得墨西哥藝術更普適的定義。科羅內爾在作品中關注無家可歸者的生活，並為他們繪上優雅與尊嚴，使其好似貴族一般。《「卡波若」（之二）》描繪了三位受歡迎的戲劇演員，正在一種名為「Carpas」的便攜帳篷中表演。另一幅科羅內爾作品，《祖父》，則是一個對於瀕死之人的研究。情節通過強勁的繪圖與陰沉顏料的綜合來展現。

得益於「斷裂」的反抗，下一代墨西哥藝術家才得以更自由地探索多樣的風格。此代中的兩位藝術家截然不同。阿爾弗雷多‧卡斯塔尼達（生於一九三八年）著迷於類自傳式作品以及擁有長鬍鬚的肥胖人物。《揮手致意》的特點是一隻脫離軀體的手臂的輪廓，此作品是卡斯塔尼達風格的絕佳範例。與此相反，艾美路‧奧爾蒂斯（生於一九三六年）則回歸了墨西哥鄉村景色，以一種簡練樸實的風格表現，比如《男孩》。

瓦哈卡運動

過去數十年中，墨西哥最重要的藝術運動起源於瓦哈卡，以充滿生機的顏色與對前西班牙時期藝術傳統的新解讀為特點。

羅勳奴‧塔馬約（一八九九年至一九九一年）是瓦哈卡運動的主要代表人物。塔馬約自幼失去雙親，少年時以販賣水果謀生，之後到國家博物館工作，負責為每件前西班牙時期的館藏繪製圖像與製作編目。這段經歷徹底改變了塔馬約，使其在前西班牙時期的作品與墨西哥強烈色彩傳統的基礎上，構思出一種新式的墨西哥藝術。他居於紐約，將其藝術語言連結至更廣闊的當代藝術世界。薩潘塔一家與塔馬約建立起親密的友誼。是次展覽的數件作品代表了塔馬約的藝術：兩件石版畫《黑色維納斯》與《輪廓》，素描《人》，綜合技法《女孩》。由塔馬約等人聯合發展出的「綜合技法」，賦予圖像豐

富的層次與深度。塔馬約總在尋找合成的模式。這些作品因其簡約的線條與顏色而廣受讚譽。

雖然塔馬約已經成為世界聞名的藝術大師，但他依然利用一切機會鼓勵、提拔藝術新人。他的影響力遍佈墨西哥，特別是一些藝術家的作品，比如，納亞里特人弗拉迪米爾‧柯拉（生於一九五一年），參見《門口的女人》，以及瓜達拉哈拉人亞歷杭德羅‧科倫加（生於一九四八年）。雖然科倫加也從一些藝術運動比如「美國普普藝術」中獲得啟發，但在是此展覽的作品《雨靈》中，塔馬約的影響尤為明顯。塔馬約對其瓦哈卡同鄉的幫助與提拔是卓有成效的，特別是羅多爾福‧摩拉利斯與弗朗西斯科‧托萊多。

羅多爾福‧摩拉利斯（一九二五年至二零零一年）大器晚成，是一位特別含蓄、謙卑的藝術家，曾孜孜不倦地從事藝術教師事業三十年之久。某次在雕刻家蓋麗斯‧卡布瑞拉的家中籌備聚會之時，摩拉利斯將自己的拼貼作品用作裝飾，而卡布瑞拉則發現了他的藝術價值，還為他組織一次展覽，之後塔馬約亦對摩拉利斯的藝術讚不絕口，並開始資助他。薩潘塔一家結識摩拉利斯之後，曾留他小住時日，並以摩拉利斯的名義舉辦了一次聚會。極為害羞的摩拉利斯知道自己不善言談，只能專注於繪畫，故而麗貝卡‧薩潘塔陪他前往當地的藝術商店購買畫筆、顏料與畫布，當賓客抵達之後，羅多爾福‧摩拉利斯才開始創作精美的繪畫與拼貼作品。

羅多爾福‧摩拉利斯的作品在國際藝術市場取得巨大的成功，但他對收入的使用卻更引人注目。他一生保持低調簡樸，而將收入投進基金會，致力於修復家鄉奧科特蘭的殖民時期建築。是次展覽選擇的三幅摩拉利斯作品是魔幻現實主義的傑作，包括兩件布面油畫以及一件拼貼作品。

塔馬約發掘的另一位藝術家是弗朗西斯科‧托萊多（生於一九四零年），現被公認為是在世的最偉大的墨西哥藝術家。《非馬》是托萊多想象力的絕佳體現。與摩拉利斯一樣，托萊多亦對其故鄉投入巨大，他籌建了許多機構，包括一間藝術圖書館，一間盲人圖書館與一間音樂圖書館。托萊多是文化元老，致力於保護瓦哈卡的文化遺產。托萊多的藝術穿透生命的神聖維度，在嚴謹與簡約中探索古老神話與神秘魔幻。

米格爾・卡布瑞拉

謝拉度・牟利羅

迪亞高・里維拉

羅拔圖・蒙特內格羅

阿爾弗雷多・拉莫斯・馬天尼斯

費德里戈・坎圖

勞爾・安吉亞諾

荷西・克萊門特・奧羅茲科

芙烈達・卡蘿

艾美路・奧爾蒂斯

赫蘇斯・格雷羅・加雲

弗朗西斯科・托萊多

阿爾弗雷多・卡斯塔尼達

大衛・阿爾法羅・西凱羅斯

弗朗西斯科・蘇尼加

古斯塔沃・蒙度亞

羅勳奴・塔馬約

荷西・路爾斯・奎瓦斯

亞歷杭德羅・科倫加

拉斐爾・科羅內爾

奧爾加・歌絲達

李奧諾拉・卡林頓

弗拉迪米爾・柯拉

阿爾弗雷多・扎爾斯

羅多爾福・摩拉利斯

MIGUEL CABRERA

GERARDO MURILLO (DR. ATL)

DIEGO RIVERA

ROBERTO MONTENEGRO

ALFREDO RAMOS MARTÍNEZ

FEDERICO CANTÚ

RAÚL ANGUIANO

JOSÉ CLEMENTE OROZCO

FRIDA KAHLO

EMILIO ORTIZ

JESÚS GUERRERO GALVÁN

FRANCISCO TOLEDO

ALFREDO CASTAÑEDA

DAVID ALFARO SIQUEIROS

FRANCISCO ZÚÑIGA

GUSTAVO MONTOYA

RUFINO TAMAYO

JOSÉ LUIS CUEVAS

ALEJANDRO COLUNGA

RAFAEL CORONEL

OLGA COSTA

LEONORA CARRINGTON

VLADIMIR CORA

ALFREDO ZALCE

RODOLFO MORALES

墨　世　鼎　新

MEXICAN
MODERNITY

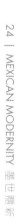

OUR LADY OF SORROWS
痛苦聖母
Oil on canvas 布面油彩
1761
38.1 x 29.8 cm

GERARDO MURILLO (DR. ATL)

PAISAJE CON LUNA LLENA (LANDSCAPE WITH FULL MOON)
望境
Charcoal on board 木板炭筆
Undated 日期不詳
44.4 x 58.4 cm

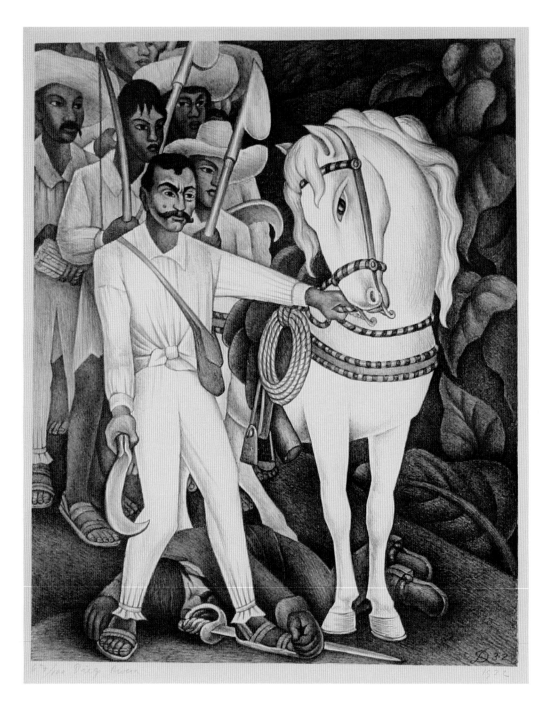

ZAPATA
薩帕塔
Lithograph 石版畫
1932
41.2 x 31.7 cm

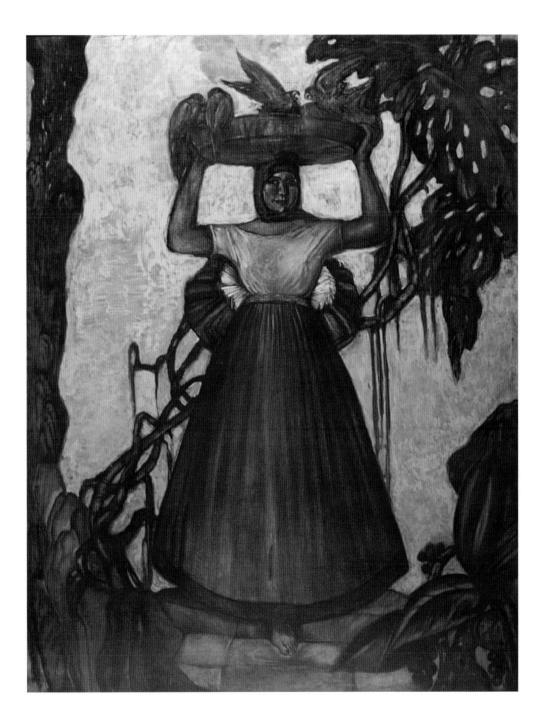

THE BIRD WOMAN
鴿女
Oil on canvas 布面油彩
1937
167 x 128.2 cm

ALFREDO RAMOS MARTÍNEZ

阿爾弗雷多・拉莫斯・馬天尼斯

RETURNING HOME FROM THE MARKET
歸家
Painting, mixed media, tempera and charcoal on paper 綜合媒介，紙面蛋彩及炭筆
c. 1940
67.3 x 51.1 cm

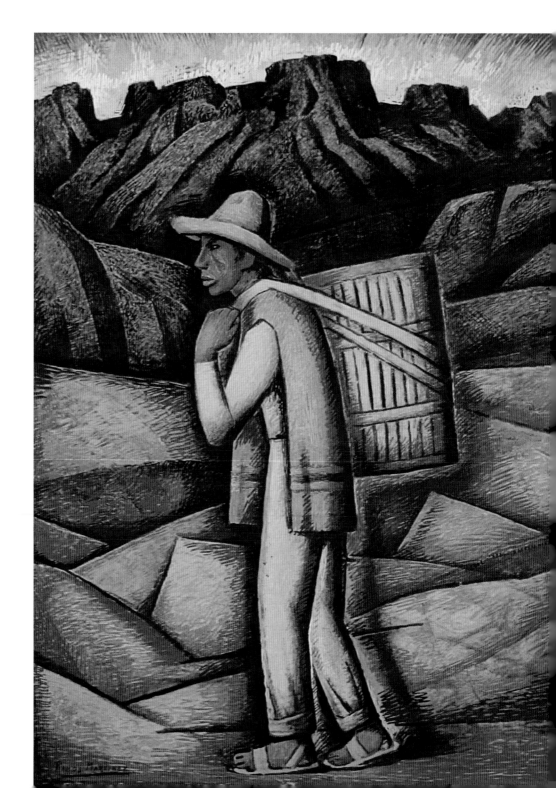

FEDERICO CANTÚ

費德里戈·坎圖

LA DESPEDIDA (THE FAREWELL)
告別
Gouache on paper 紙面水粉
Undated 日期不詳
54.6 x 49.5 cm

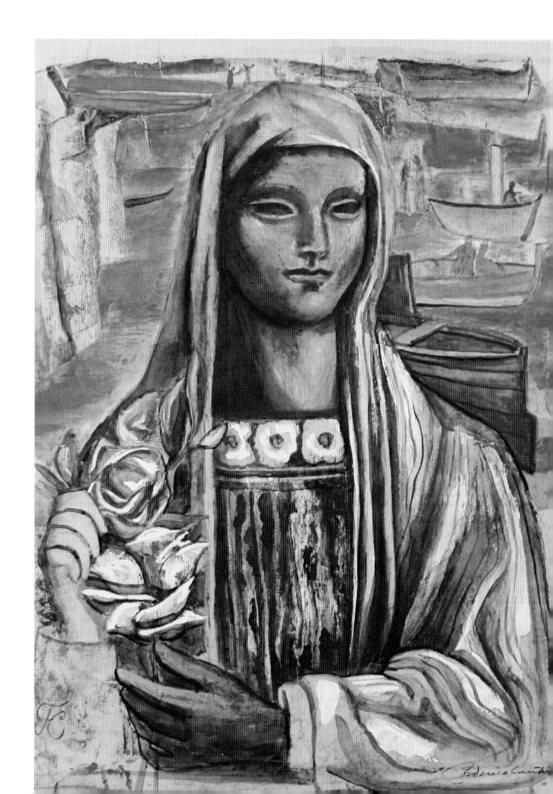

RAÚL ANGUIANO 勞爾・安吉亞諾

MENDIGA (BEGGAR)
乞婦
Oil on canvas 布面油彩
1945
87.6 x 83.3 cm

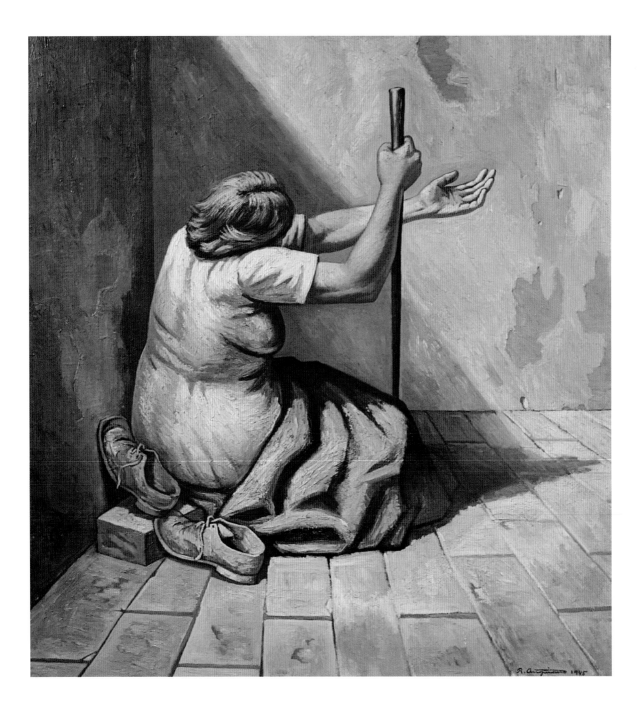

JOSÉ CLEMENTE OROZCO

荷西・克萊門特・奧羅茲科

MUJER SENTADA (SEATED WOMAN)
坐著的女人
Oil on paper 布面油彩
1946
52.7 x 36.8 cm

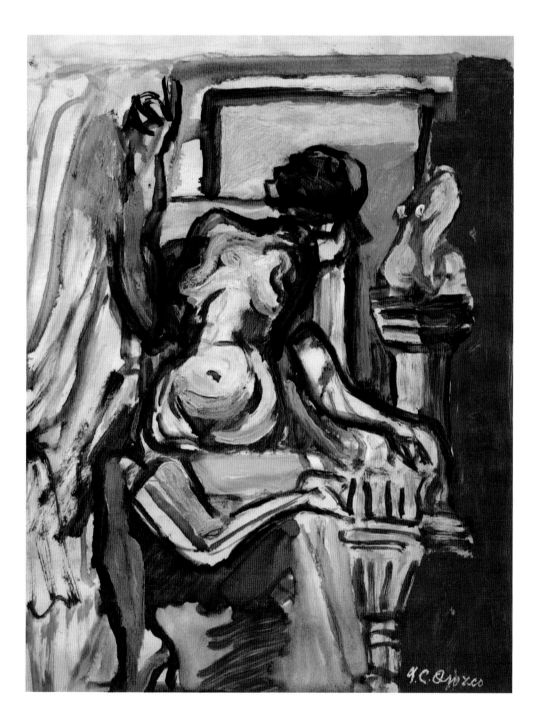

FRIDA KAHLO

芙烈達・卡蘿

POR LA PAZ (FOR PEACE)
和
Ink and coloured pencil on paper 紙面墨水及彩色鉛筆
1952
19 x 10.1 cm

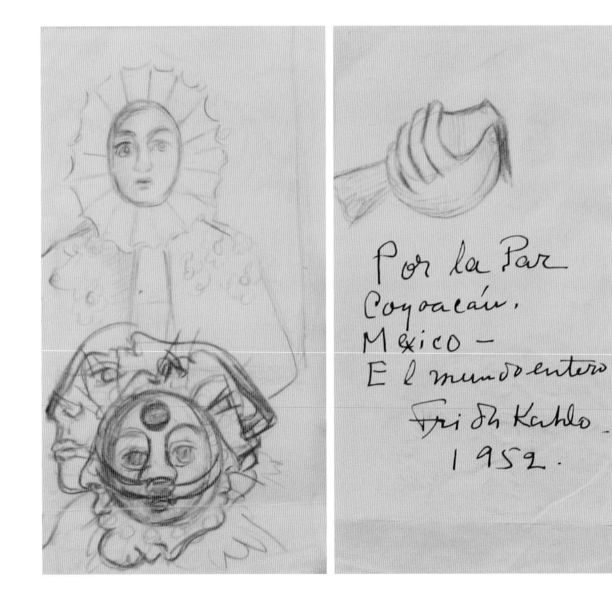

NIÑA CON FLORES (GIRL WITH FLOWERS)
女孩與花
Watercolour on rice paper 米紙水彩
1954
38.1 x 25.4 cm

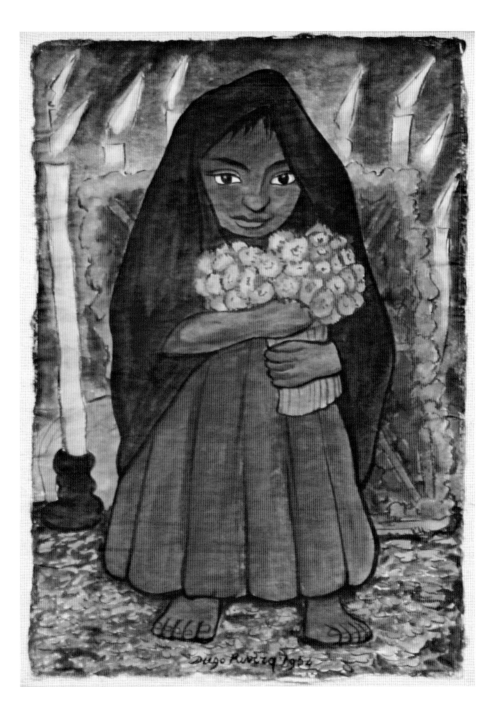

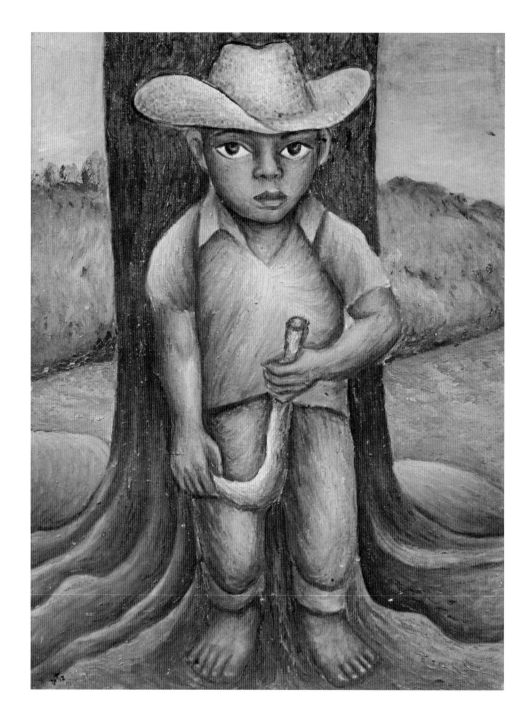

NIÑO (BOY)
男孩
Oil on canvas 布面油彩
Undated 日期不詳
62.2 x 47 cm

JESÚS GUERRERO GALVÁN

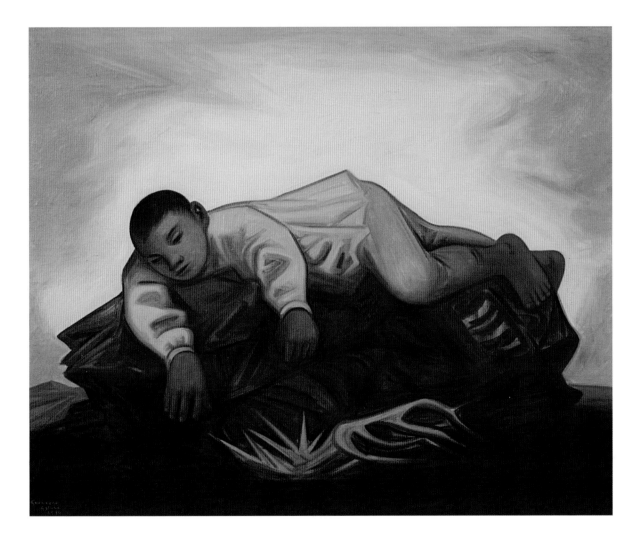

UNTITLED
無題
Oil on canvas 布面油彩
1956
80 x 100 cm

FRANCISCO TOLEDO

COMPOSITION AU CHEVAL (COMPOSITION WITH HORSE)
非馬
Watercolour on paper 紙面水彩
1960
47.6 x 67.3 cm

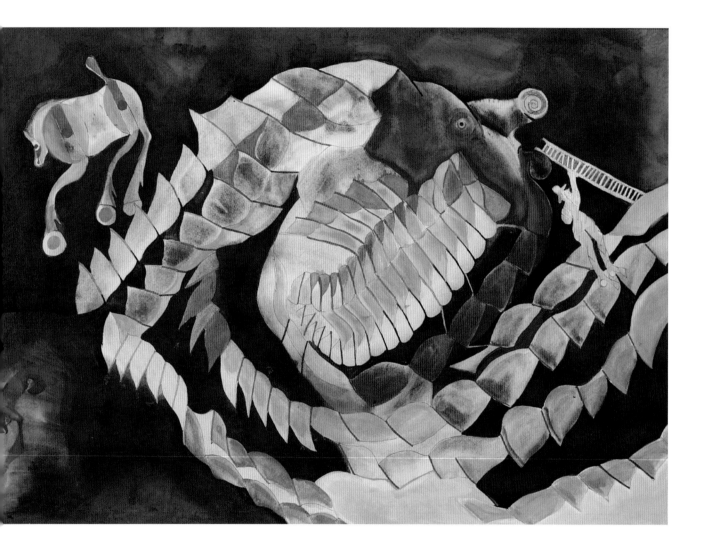

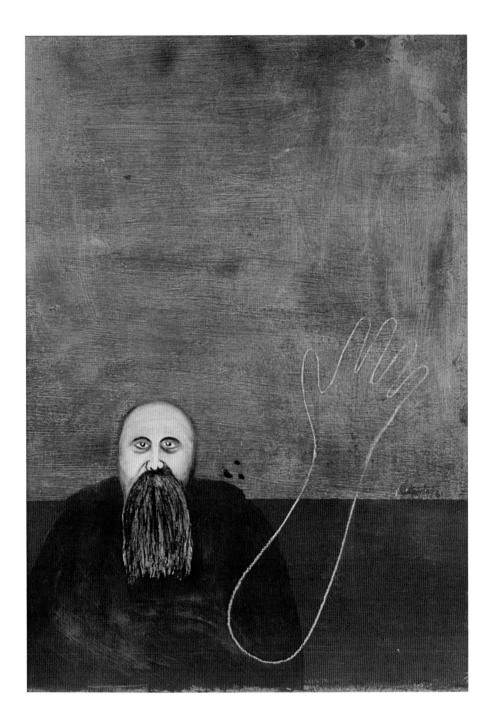

SALUDO
揮手致意
Mixed media on board 木板綜合媒介
1961
83.1 x 58.7 cm

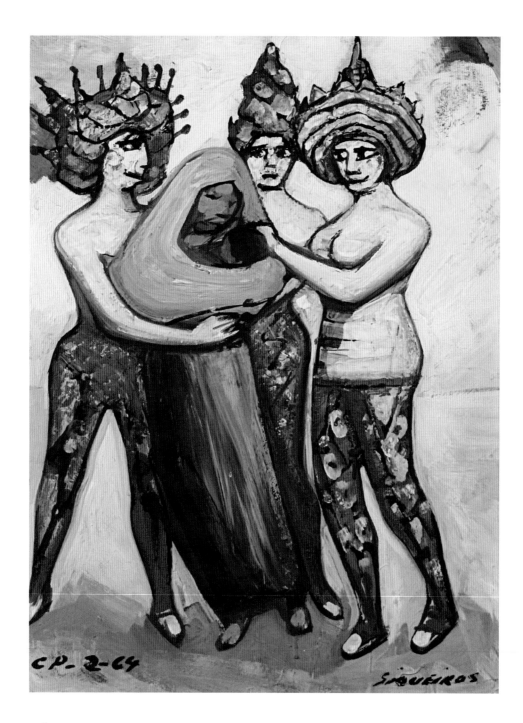

FILANTROPÍA EN VACACIONES (PHILANTHROPY ON VACATION)
假中善人
Oil on panel 板上油彩
1964
49.5 x 36.8 cm

MADRE Y NIÑO (MOTHER AND CHILD)
母與子
Watercolour, crayon and white chalk on paper 紙面水彩、蠟筆及白粉筆
1966
64.7 x 49.5 cm

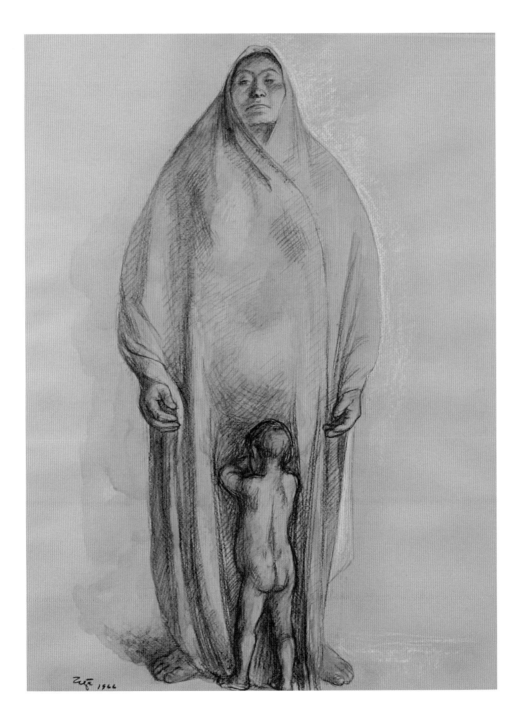

GUSTAVO MONTOYA

DOS NIÑOS, UNO JUGANDO (TWO CHILDREN, ONE PLAYING)
兩個孩童，一人在玩
Oil on canvas 布面油彩
1966
45.7 x 60.9 cm

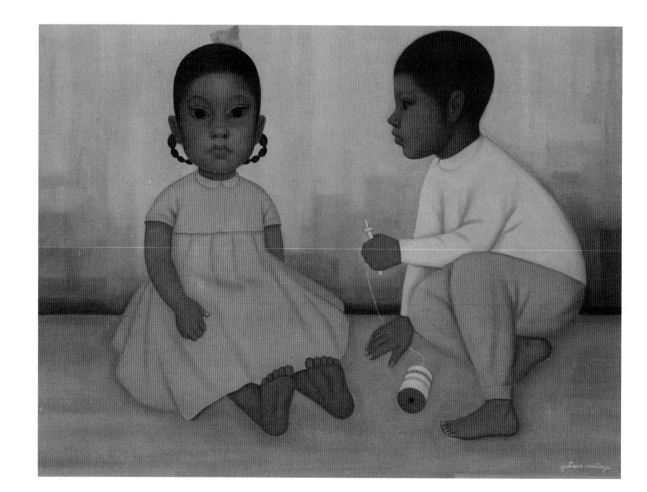

FIGURA (FIGURE)
人
Pencil and crayon on paper 紙面鉛筆及蠟筆
1966
33.6 x 25.4 cm

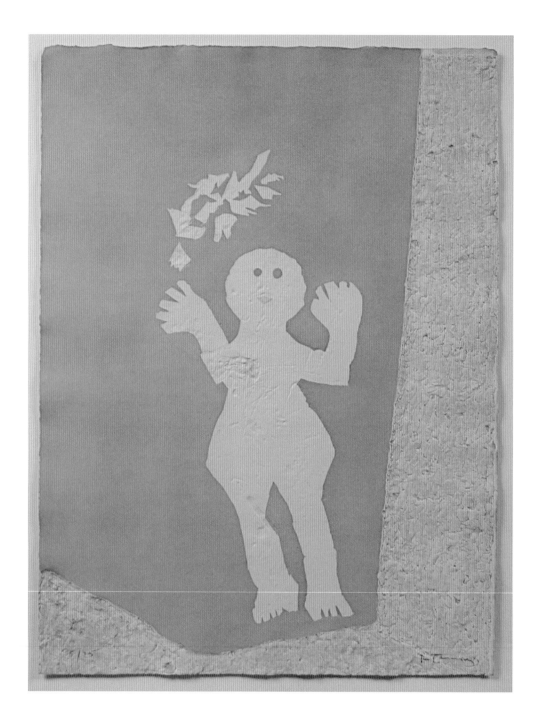

PERFIL (PROFILE)
輪廓
Lithograph 石版畫
1968
85.7 x 66 cm

RUFINO TAMAYO

羅勳奴・塔馬約

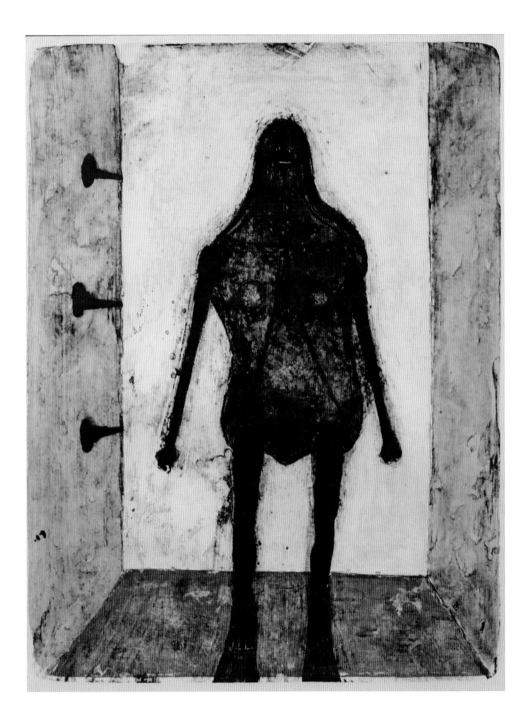

BLACK VENUS
黑色維納斯
Lithograph 石版畫
1968
69.2 x 52.7 cm

JOSÉ LUIS CUEVAS 荷西・路爾斯・奎瓦斯

FREQUENTAS OF 42ND STREET (42ND STREET REGULARS)
四十二街常客
Watercolour and ink on paper 紙面水彩及墨水
1968
26.9 x 34.2 cm

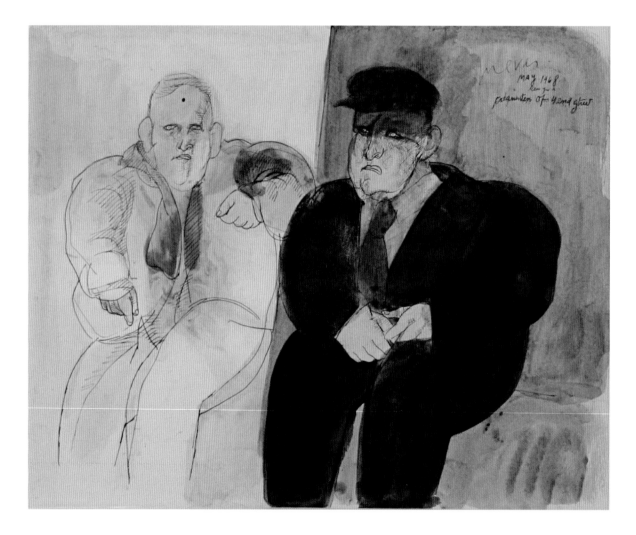

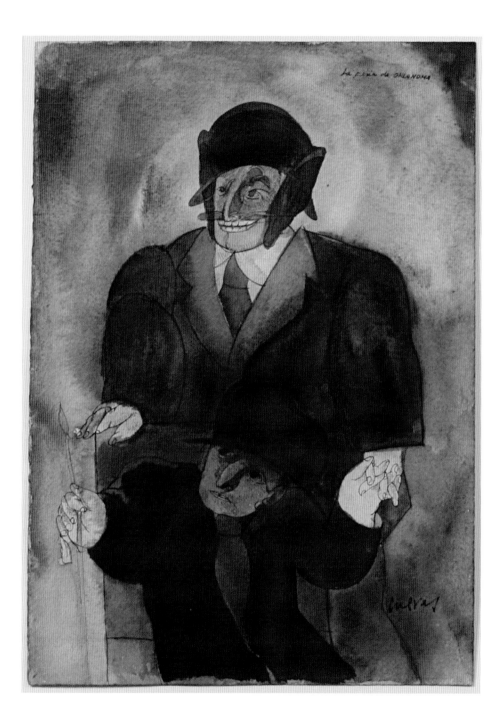

LA FERIA DE OKLAHOMA (OKLAHOMA FAIR)
奧克拉荷馬市場
Watercolour and ink on paper 紙面水彩及墨水
Undated 日期不詳
34.9 x 25 cm

FRANCISCO ZÚÑIGA

MUJERES EN EL MERCADO (WOMEN AT THE MARKET)
市集中的女人
Watercolour and charcoal on paper 紙面水彩及炭筆
1968
67.3 x 49.8 cm

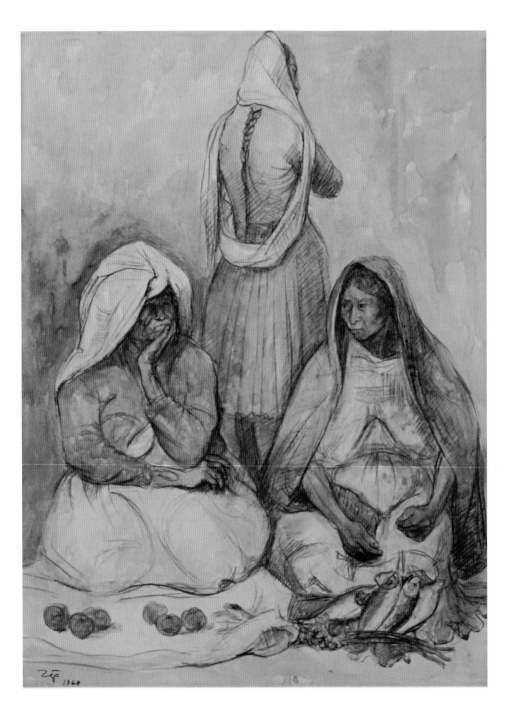

ALEJANDRO COLUNGA

MAGO DE LA LLUVIA
(RAIN MAGICIAN)
雨靈
Oil on canvas 布面油彩
c. 1970–1989
138.7 x 111.7 cm

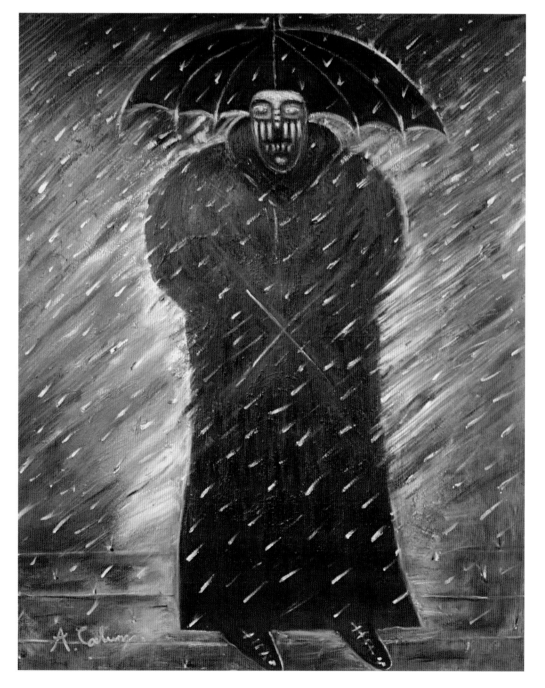

JOSÉ LUIS CUEVAS

荷西・路爾斯・奎瓦斯

EL OBRADOR DE JUAN CARREÑO (THE WORKROOM OF JUAN CARREÑO)
胡安・卡雷尼奧的工作室
Coloured pencil, pen and ink on paper 紙面彩色鉛筆、鋼筆及墨水
1973
73.6 x 99.6 cm

RAÚL ANGUIANO 勞爾・安吉亞諾

ORIENTAL BEAUTY
東方麗人
Oil on canvas 布面油彩
1976
121.9 x 60.9 cm

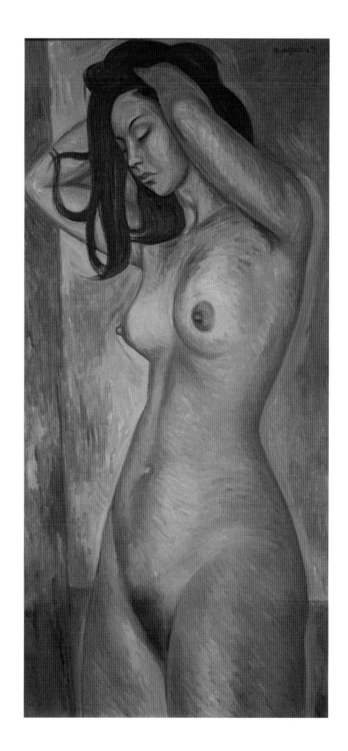

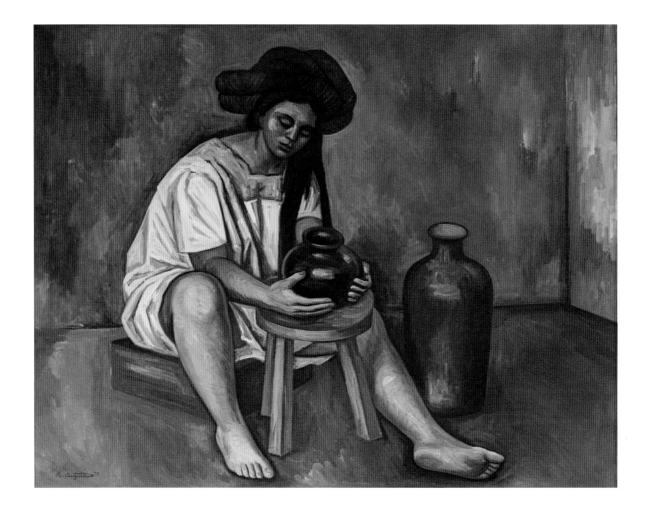

ALFARERA (POTTER)
陶女
Oil on canvas 布面油彩
1977
100.3 x 130.8 cm

RAFAEL CORONEL

拉斐爾・科羅內爾

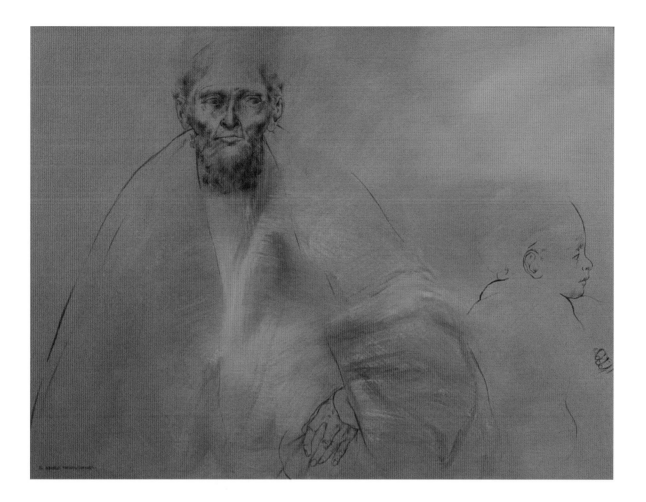

THE GRANDFATHER
祖父
Watercolour and pencil on paper 紙面水彩及鉛筆
1978
72.3 x 96.5 cm

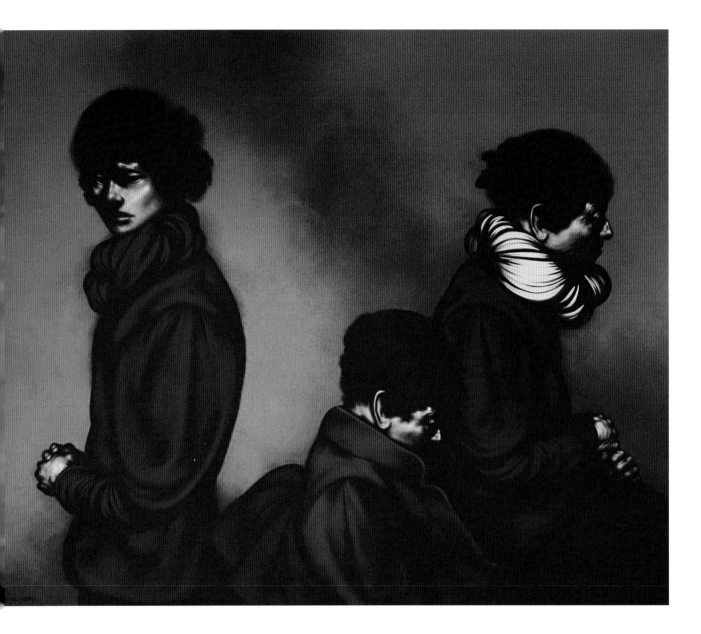

CARPEROS II
「卡波若」（之二）
Oil on canvas 布面油彩
1980
123.1 x 148.5 cm

RUFINO TAMAYO

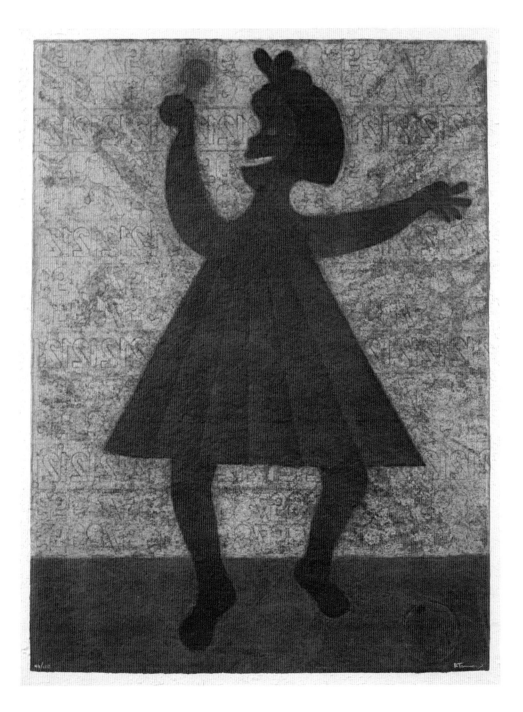

NIÑA (GIRL)
女孩
Mixograph 綜合技法
1981
100.3 x 73.6 cm

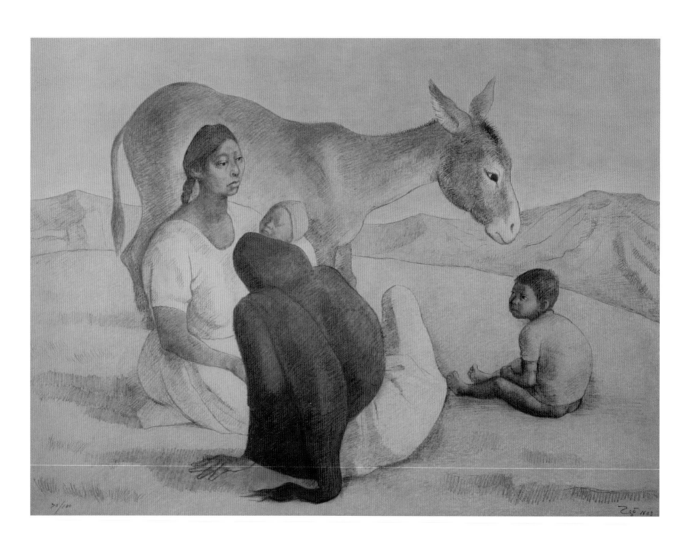

FAMILIA CON BURRO (FAMILY WITH BURRO)
一家人與小驢
Lithograph 石版畫
1983
74.9 x 54.6 cm

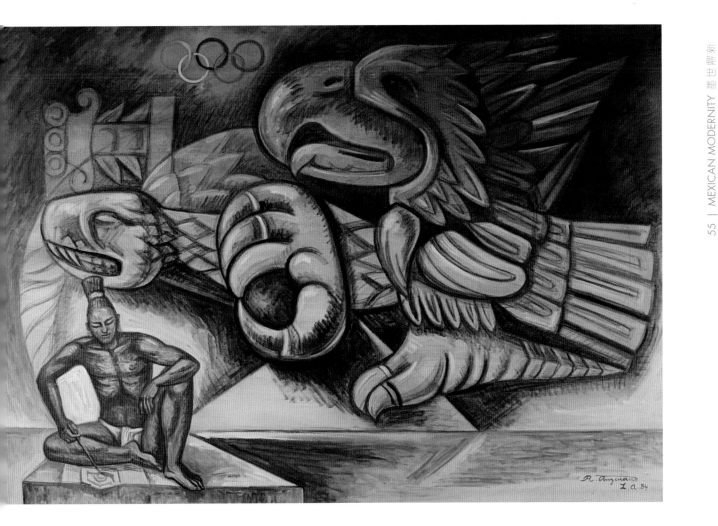

PRESENCIA DEL HOMBRE MAYA EN LAS OLIMPIADAS
(MAYAN MAN'S PRESENCE AT THE OLYMPICS)
奧運會中的瑪雅人
Oil on canvas 布面油彩
1984
158.7 x 210.8 cm

OLGA COSTA 奧爾加・歌絲達

CASA AZUL (BLUE HOUSE)
藍屋
Pastel on Paper 紙面粉彩
1985
47.6 x 62.2 cm

LEONORA CARRINGTON

TUESDAY (STATE II)
禮拜二
Lithograph 石版畫
1987
52.3 x 81.2 cm

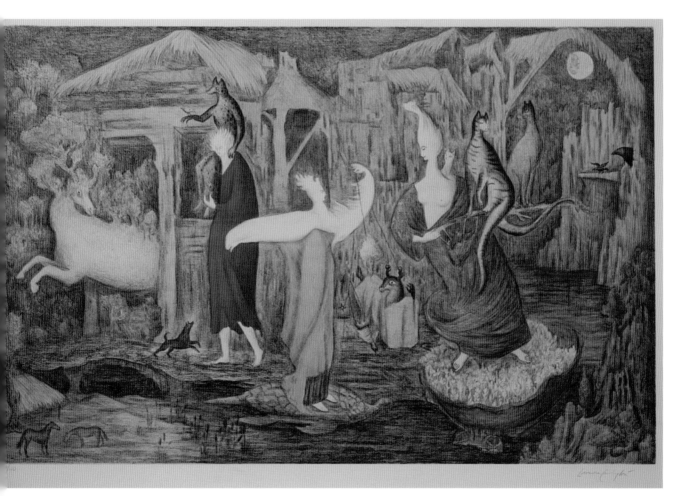

VLADIMIR CORA 弗拉迪米爾 · 柯拉

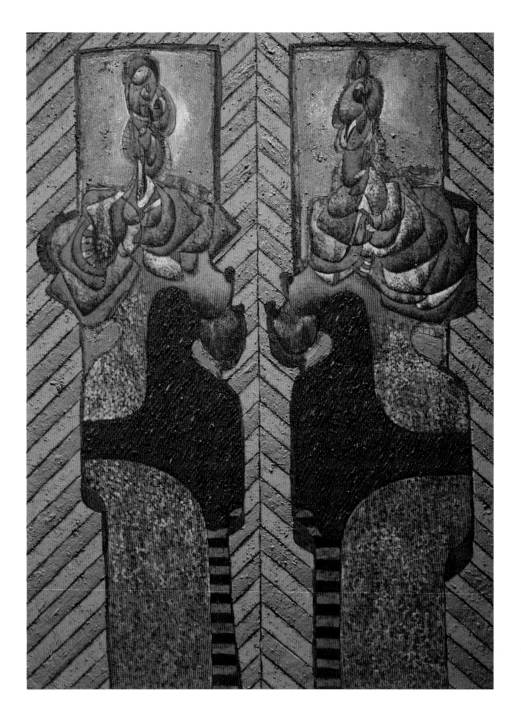

MUJERES EN LA PUERTA (WOMEN AT THE DOOR)
門口的女人
Oil and acrylic on canvas 布面油彩及丙烯顏料
1988
173.6 x 128.9 cm

ALFREDO ZALCE

阿爾弗雷多·扎爾斯

STILL LIFE WITH WATERMELON
靜物西瓜
Charcoal on paper 紙面炭筆
1993
33.6 x 49.5 cm

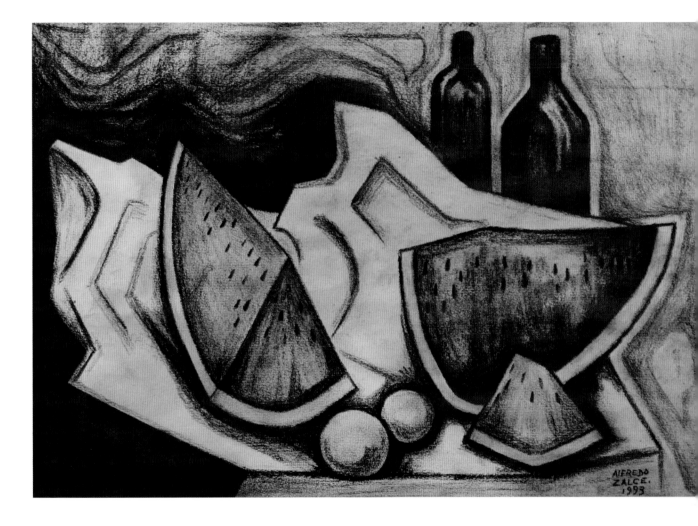

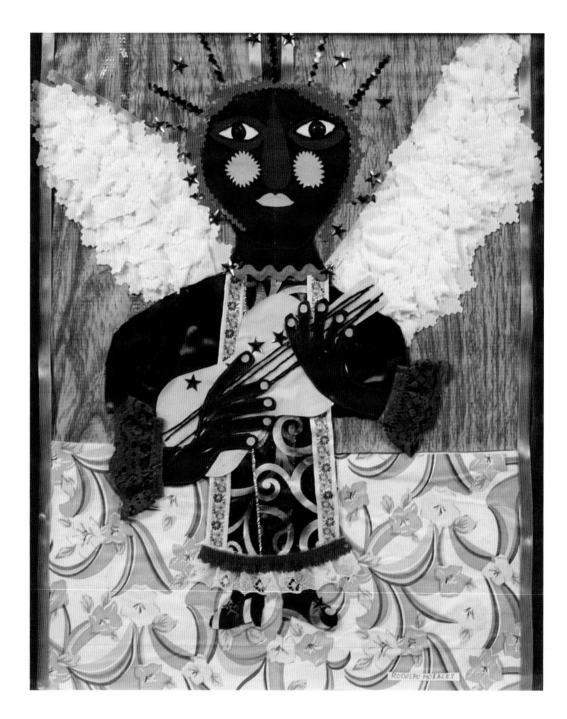

UNTITLED
無題
Collage on wallpaper and white fabric 拼貼墙紙及白布
Undated 日期不詳
49.8 x 40.6 cm

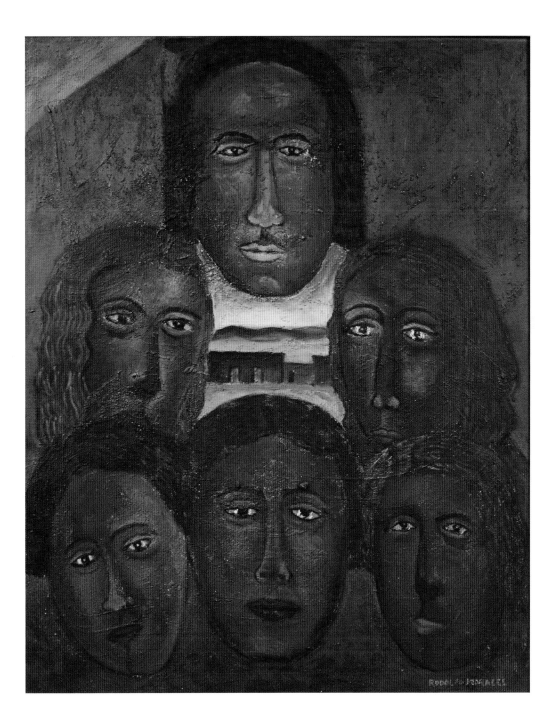

UNTITLED (SEIS CABEZAS) (UNTITLED [SIX HEADS])
無題（六首）
Oil on canvas 布面油彩
Undated 日期不詳
96.5 x 77.4 cm

RODOLFO MORALES

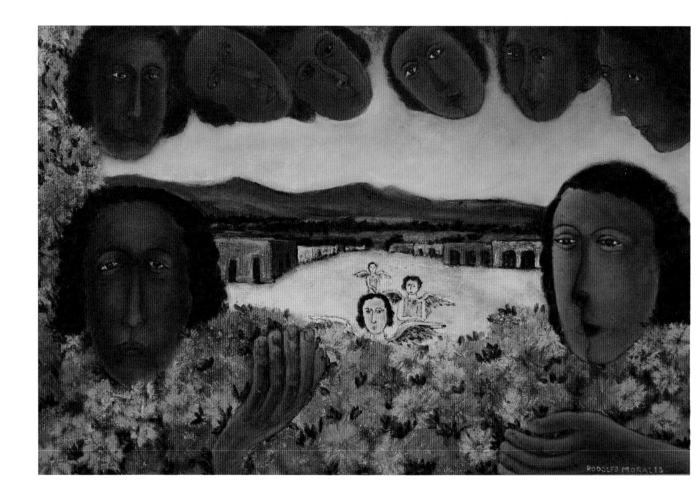

UNTITLED
無題
Oil on canvas 布面油彩
1999
59.6 x 90.1 cm

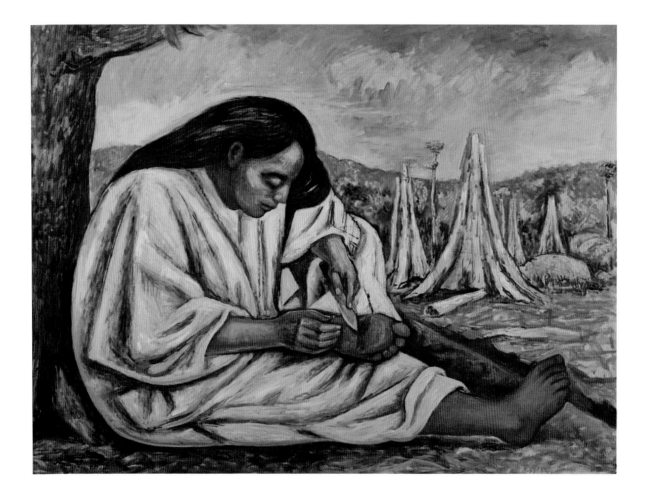

LA ESPINA (THORN)
刺
Oil on canvas 布面油彩
2002
90.1 x 120.6 cm

ORGANISED BY 主辦

香港大學美術博物館
University Museum and Art Gallery
The University of Hong Kong

SUPPORTED BY 支持

MÉXICO
CONSULADO GENERAL DE MÉXICO
EN HONG KONG Y MACAO

ESTADOS UNIDOS MEXICANOS

五十
50
1965 · 2015
MÉXICO-HONG KONG-MACAO

AMEXCID
MEXICAN AGENCY
FOR INTERNATIONAL
DEVELOPMENT COOPERATION

UNITED STATES-MEXICO CULTURAL AND EDUCATIONAL FOUNDATION
FUNDACIÓN CULTURAL Y EDUCATIVA MÉXICO-ESTADOS UNIDOS